31 Days of Inspiration
Nichole Fausey

© 2012 Nichole Fausey. All rights reserved.
ISBN 978-1-105-82856-0

A Word About Inspiration	1
Crayon Family	3
Old Photo	5
Full Page Favorite	7
Ink Blots	9
Think Outside the Box	13
Venting Session	15
Memento of a Walk	19
Watercolor Me Lovely	21
Quote of the Day	25
Rub Down	27
Rip it Up	29
Shapes of Life	31
Sound Painting	33
Alien Invasion	37
Draw What You See	39
Word Play	41
Faces in the Magazines	43
Free Color	45
Scratch My Back	47
Toe the Line	51
Childlike Animal	53
Alphabet Preference	55
Unusual Stamps	57
Musical Meaning	61
Ball Point Picture	63
Impossible	65
Shaping Fun	67
Scribble	69
Traditional Image	71
Artist Admiration	73
Life Quote	75
Finishing Thoughts	77

Contents

As an artist, I know the feeling of being uninspired. It's useless to deny it—sometimes we get burnt out. After spending years collecting fun exercises that foster inspiration, I've decided to share them with my fellow artists. This book consists of my favorite exercises; the ones that work the best.

Have fun with this book. It's not for anyone else—just you. As you follow each day, make the exercises yours. Interpret them in ways that make you feel something. At the end of 31 days, You should end up with a book that inspires you as you look at it. It should be filled with everything you love, and maybe some things that you didn't know you loved.

A Word About Inspiration

Day 1

Crayon Family

Sometimes the best thing to do when you're uninspired is to return to your roots. Pick up a crayon and draw your family or those closest to you. Draw it like you did when you were six. Hold the crayon like a child would; in your fist. Let everything you've learned about fine art and professionalism go. If anyone knows something about inspiration and imagination, it's a child.

Old Photo

I know you've got some old photos lying around somewhere. Go find your favorite and paste it here. Once you've done that, give it the frame it deserves!

Day 2

Full Page Favorite

What's your favorite color? Fill the page with it. Inspiration comes easier when we can see the things we like.

Day 3

Ink Blots

Drop a small puddle of ink or food coloring in the middle of the page. Use a straw to blow the ink around in a fun abstract design. Use different colors if you think it isn't finished.

Day 4

This page has been left blank in case the ink bleeds through. Feel free to make some fun art!

Think Outside the Box
Use this grid paper in some uncommon way.

Day 5

Venting Session

What's been frustrating you lately? Get it out. Don't worry about space. There's another page for you, too.

Day 6

There you go. Doesn't that feel better?

Memento of a Walk

Get out of your house and your current state of mind. Obviously it's doing you no favors as far as inspiration goes. While you walk, search for inspiration around you. Pick something up that gives you an idea and paste it here.

Day 7

Watercolor Me Lovely

Maybe what you need is to mix it up. Try using some watercolor. Different media makes you think differently.

Day 8

This page has been left blank in case the watercolor bleeds through. Feel free to make some fun art!

Quote of the Day

Did you read something interesting today? Find a quote or passage from an article that speaks to you and post it here. Why do you like it? What does it mean to you?

Day 9

RUB DOWN

Remember when you used to do rubbings in elementary school? Do one here. Find something with a really interesting texture and capture it. You never know when it could come in handy for a future project.

Day 10

RIP IT UP

Got any construction paper nearby? Find some sheets of differently colored paper, rip it into pieces, and make a picture of something. It could be a portrait of your dog or just an abstract blob of color. Express what you feel.

Day 11

Shapes of Life

Look at the room around you. Find a view that you like best and draw it. Instead of trying to make it realistic, though, draw your surroundings using basic shapes. Use nothing more than rectangles, circles, triangles, and squares.

Day 12

Sound Painting

Turn on a song that gives you chills. As it plays, paint the emotions you feel or what the song makes you visualize. Don't forget to write down what song you listened to!

Day 13

This page has been left blank in case the paint bleeds through.
Feel free to make some fun art!

ALIEN INVASION

This one's simple. Draw an alien. No one knows what they look like, so you can't be wrong. Just have fun with it!

Day 14

Draw What You See

Time to look around you again. Pick one object. Something that gives you good memories. When you draw it, try not to look down at your paper. Trace around the edges and feel your way around it. This is commonly known as a contour drawing. Stop when you feel done. Then look down at your drawing, and don't feel bad if it looks ridiculous. Sometimes you have to laugh.

Day 15

Word Play

What are your favorite words? That may be a question you've never heard before, but I know you have some. Words that you find the most fun to say or you that are the most meaningful to you. Write them down.

Day 16

FACES IN THE MAGAZINES

Find a magazine and cut out pieces of people's faces to make a weird one. Fashion magazines are the best, because you can play with all the crazy fashion makeup. Go nuts with this. Don't let it be boring!

Day 17

Free Color

Set yourself up so you're looking at a very colorful scene. Draw or paint it, but mix up the colors. Make all the greens reds, or the blues purples. Change the way you see the world around you. Why can't grass be orange?

Day 18

Scratch My Back

Paint this entire page with any color. Before it fully dries, scratch off parts of the paint using a pushpin or even the tip of a pencil. Drawing by taking pieces of the background away causes you to think differently than you usually do.

Day 19

This page has been left blank in case the paint bleeds through.
Feel free to make some fun art!

Toe the Line

Be on the lookout for symbols, logos, or other kinds of images that you like today. Trace it so you can keep it in here among your other inspirations.

Day 20

Childlike Animal

Pull out your markers and draw your favorite animal. It's as simple as that.

Day 21

Alphabet Preference

Here's another question that you probably haven't heard before: what's your favorite letter of the alphabet? It could be the first letter of your name, or just one that has a shape you love. Find a typeface that shows off your favorite letter best and copy it here.

Day 22

Unusual Stamps

Look around your house for a few interesting textured objects. These don't have to relate to each other at all. Take some paint or ink and stamp an image on the page. It can be as simple or full as you want it to.

Day 23

This page has been left blank in case the ink or paint bleeds through. Feel free to make some fun art!

Musical Meaning

Find a song that means a lot to you lyrically. Illustrate the lyrics or a section of the lyrics here. Don't forget to write the song title and the lyrics you're illustrating.

Day 24

Ball Point Picture

I think now it's time to go for realism. After 24 days of thinking differently, try drawing a scene around you the way you see it. Use a pen, and don't get upset if you make a mistake.

Day 25

Impossible

Tell me about an idea you had that you or someone else labeled as "impossible." What made it impossible? Think about it again and see if you can figure our the problem now.

Day 26

SHAPING FUN

Choose a basic shape (rectangle, triangle, or circle), and make a design with it. You can make it minimalist or detailed.

Day 27

Scribble
Scribble on this entire page. Sometimes you need to just let go.

Day 28

Traditional Image
Set up a still life with a few of your favorite objects. Draw it realistically with a medium that you're most comfortable using.

Day 29

Artist Admiration

Find an artist that you like and copy their artistic style. We can learn a lot from the techniques of those we admire most.

Day 30

Life Quote

For the last day of your search for inspiration, let's focus on you again. Do you have a favorite quote? Something that's kept you motivated throughout your life? Put that here. Try using words cut out from magazines to add a bit of fun.

Day 31

Well, there you go! 31 days have gone by and hopefully you've spent them filling this book with all of the things that inspire you most. This book was designed to get you out of your head and to encourage you to see the world differently. I sincerely hope that has happened for you.

Use the techniques you've learned in this book in the future if you find yourself uninspired again. Keep trying new things and always find time to make art for yourself. I wish you luck!

Final Thoughts

www.ingramcontent.com/pod-product-compliance
Lightning Source LLC
Chambersburg PA
CBHW080949170526
45158CB00008B/2429